WHEN ANIMALS TURN BAD

WHEN ANIMALS TURN BAD

Summersdale Publishers Ltd
46 West Street
Chichester
West Sussex
PO19 1RP
UK

www.summersdale.com

Printed and bound in China

ISBN: 978-1-84953-537-3

Substantial discounts on bulk quantities of Summersdale books are available to corporations, professional associations and other organisations. For details contact Nicky Douglas by telephone: +44 (0) 1243 756902, fax: +44 (0) 1243 786300 or email: nicky@summersdale.com.

WHEN ANIMALS TURN BAD

Izzy Wilde

summersdale

INTRODUCTION

You may not believe it at first, but nature shows are a big cover-up. It's not all survival-of-the-fittest and competing for dominance over the waterhole. In actual fact, wild animals are only after one thing: they want to get their rocks off and they don't care how. There are lewd lemurs, obscene owls and perverted penguins, and we have the proof right here.

Take a look at the truly wild side of nature and get ready to be appalled at the kinkiness of the animal kingdom, as we reveal what happens when animals turn bad…

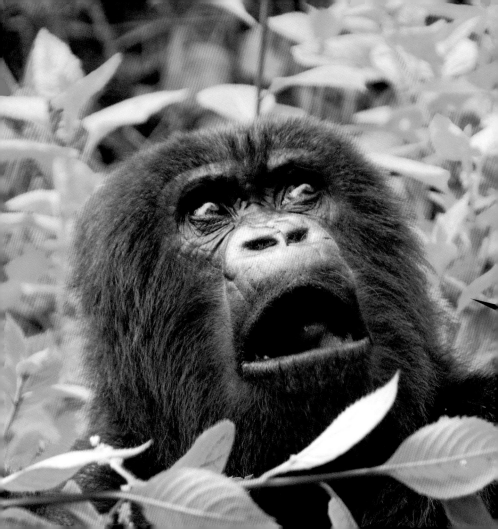

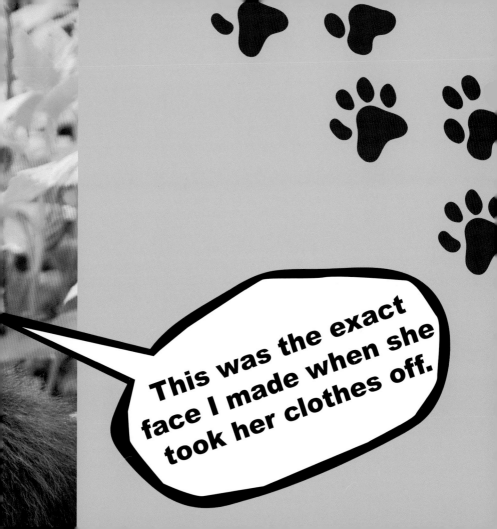

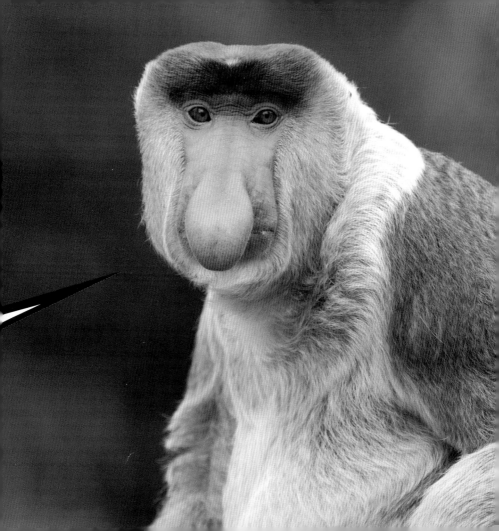

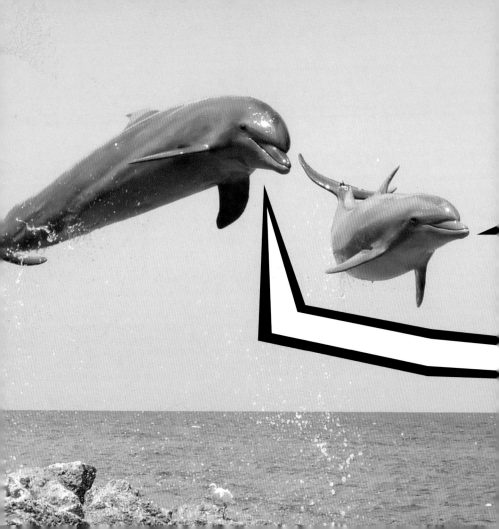

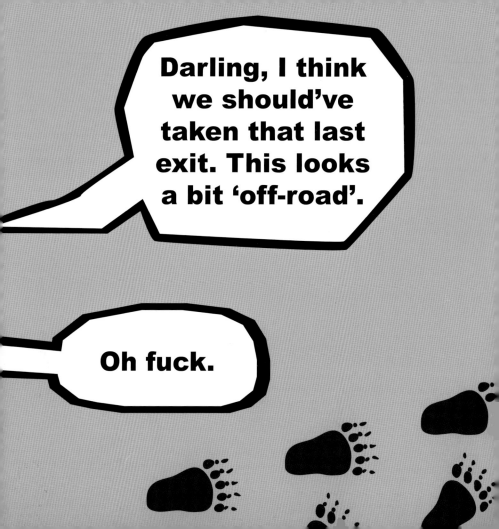

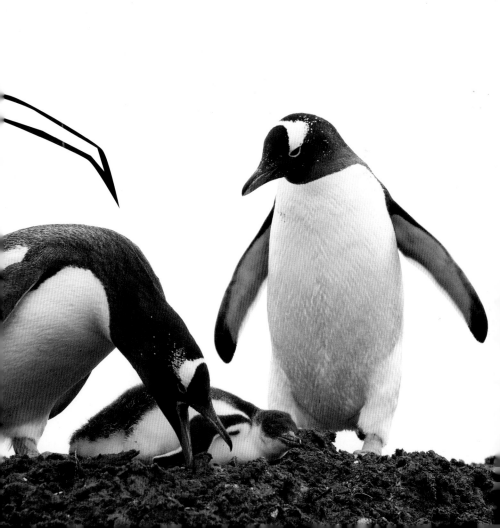

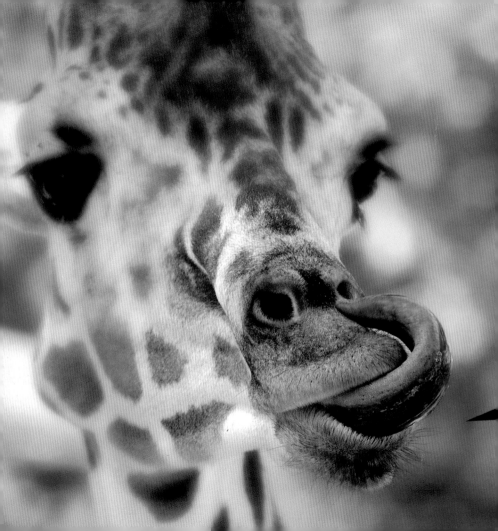

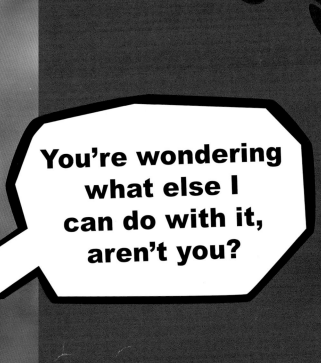

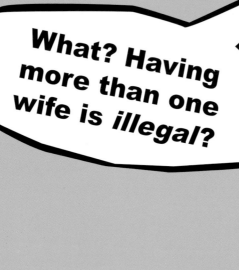

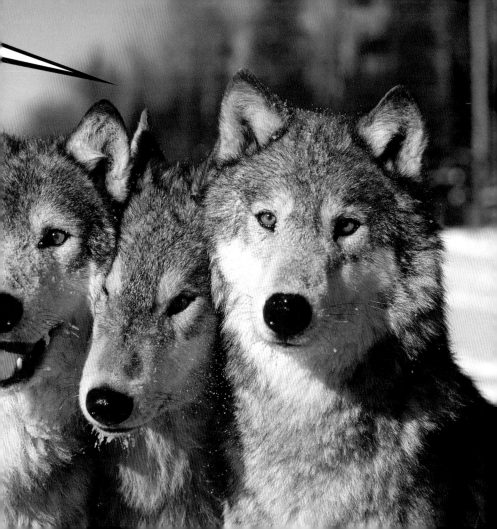

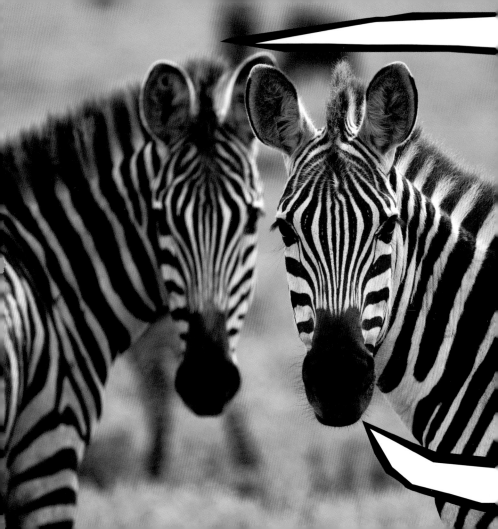

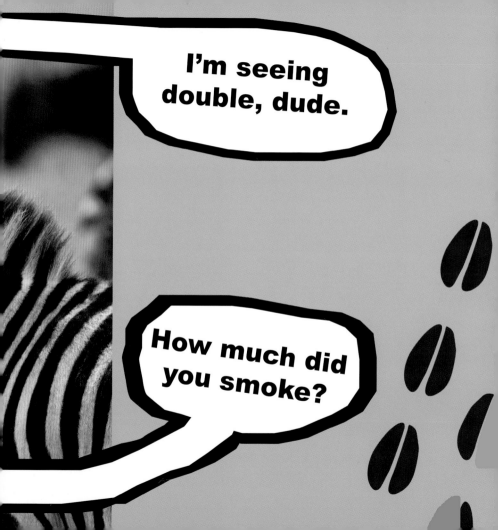

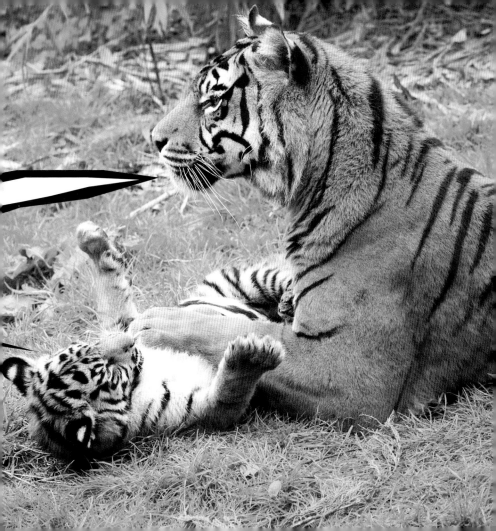

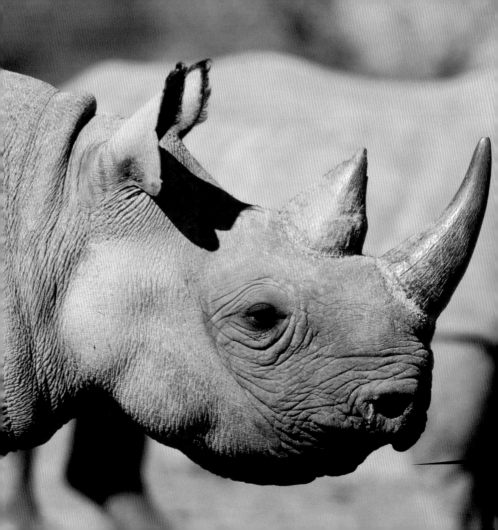

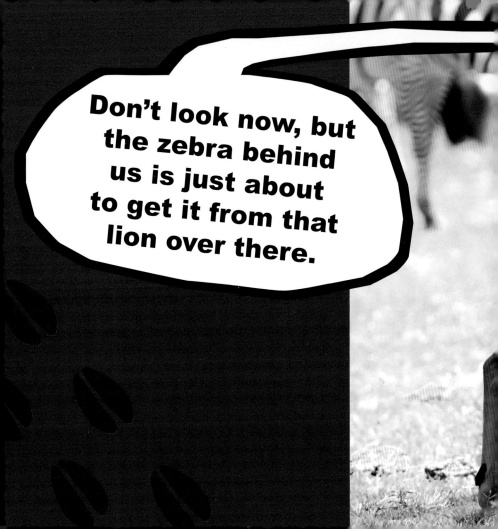

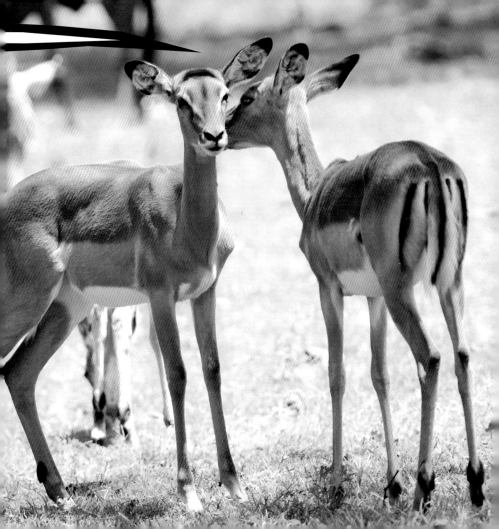

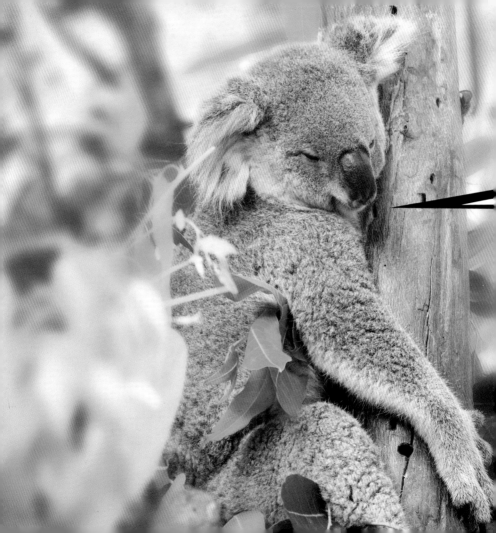

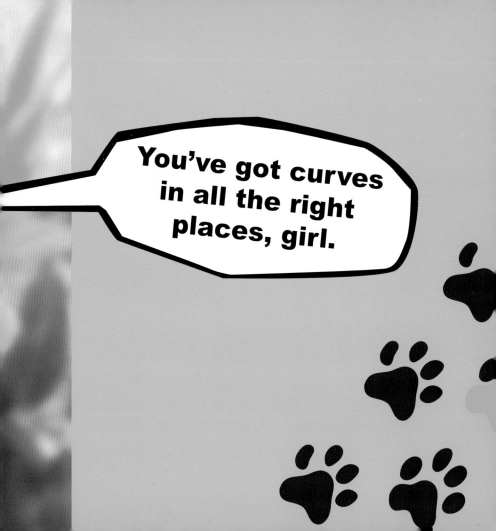

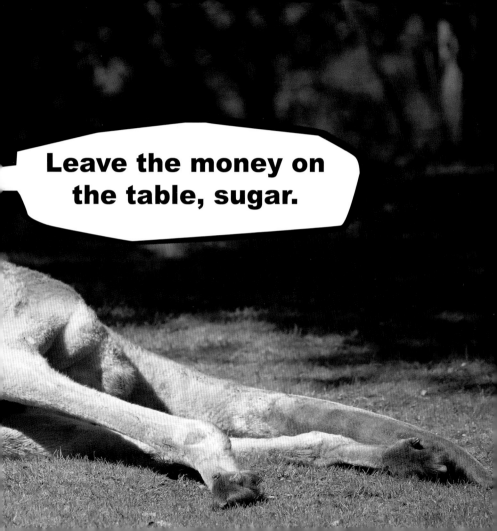

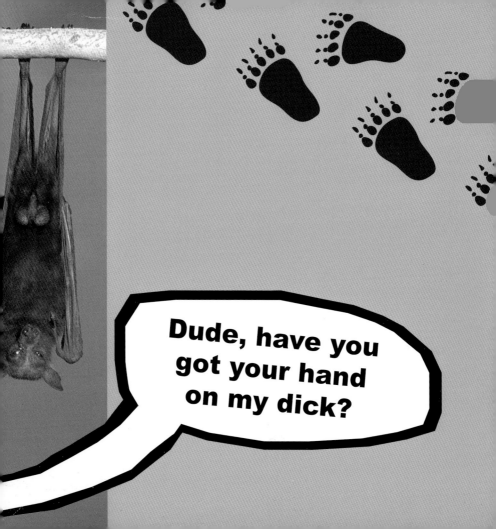

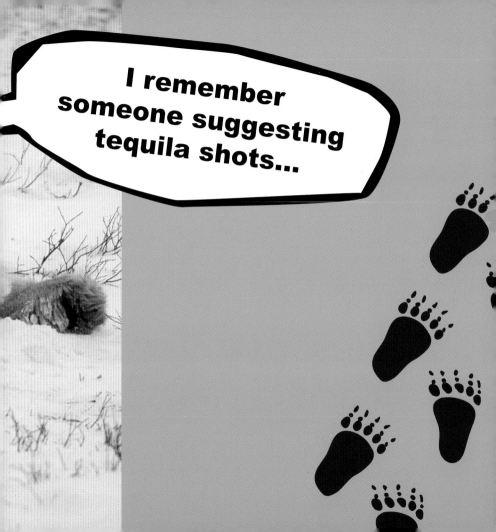

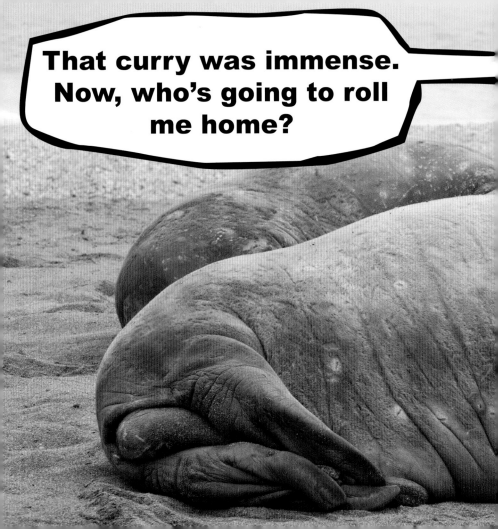

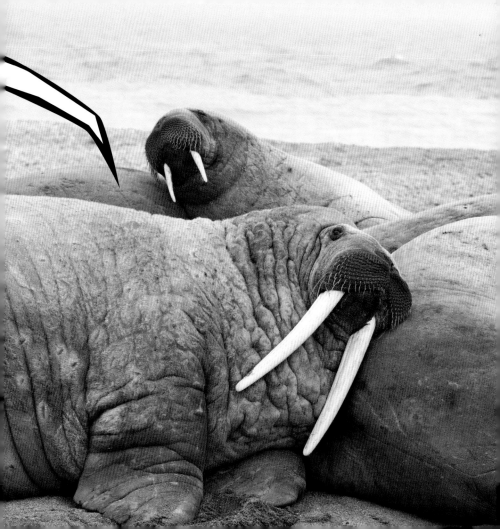

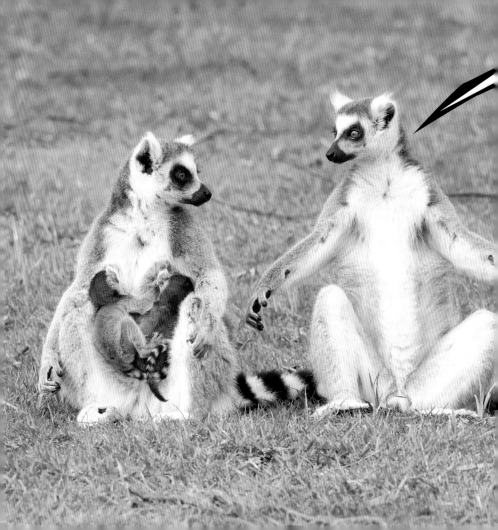

Woman, why are you always hassling me?

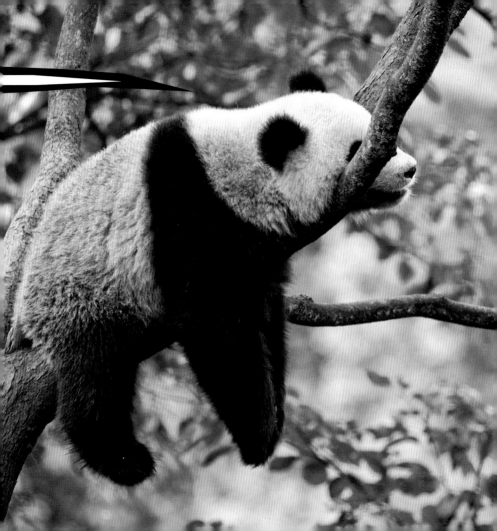

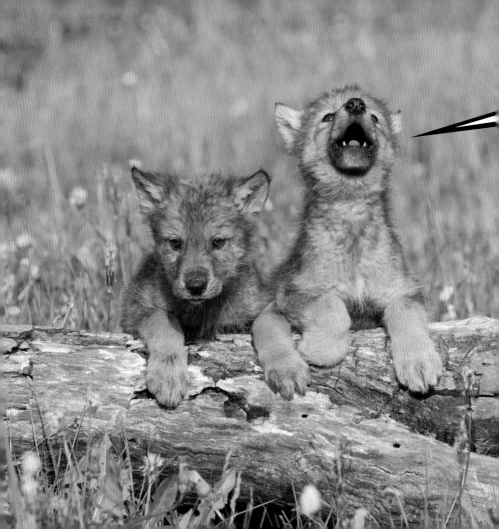

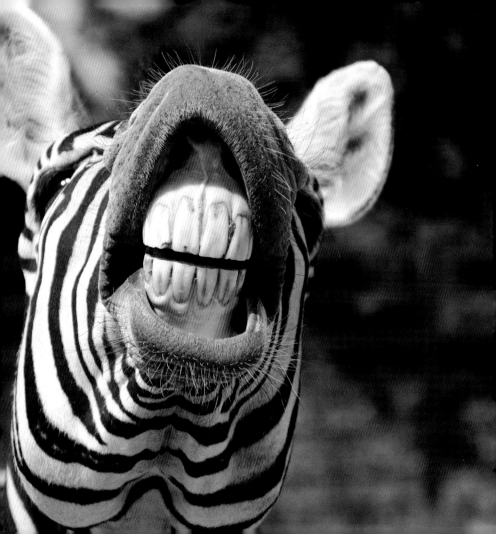

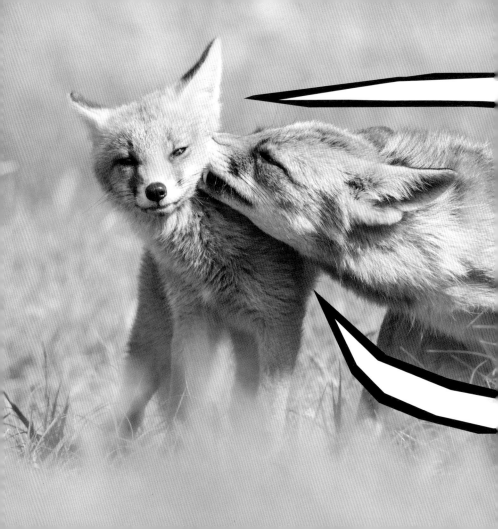

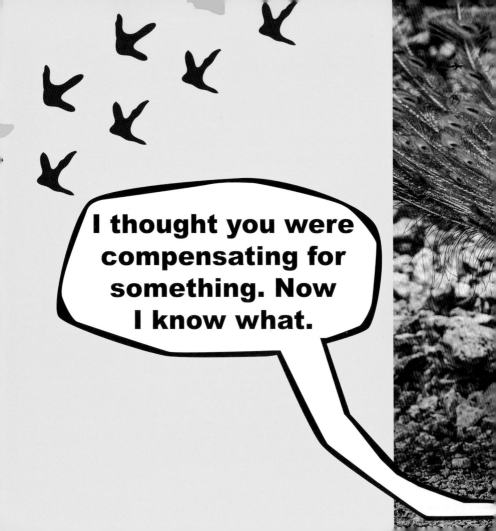

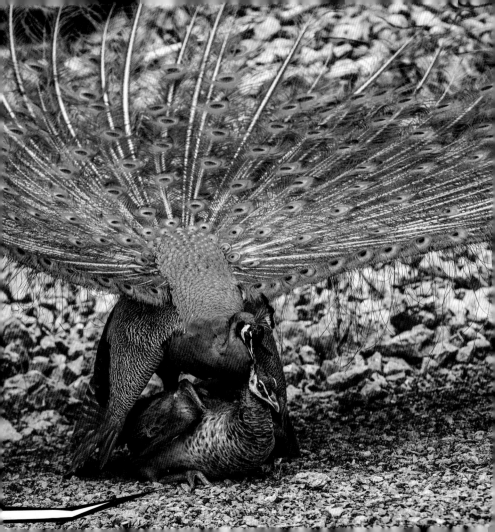

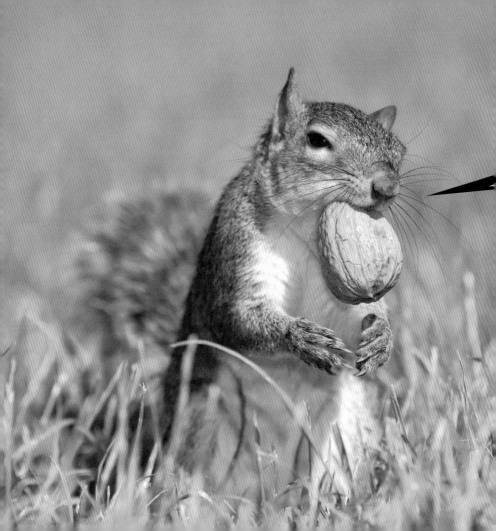

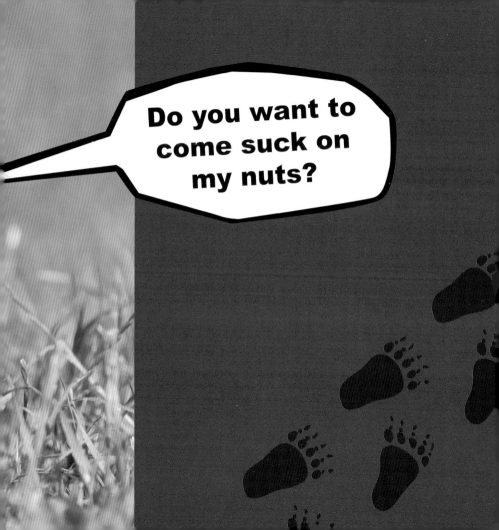

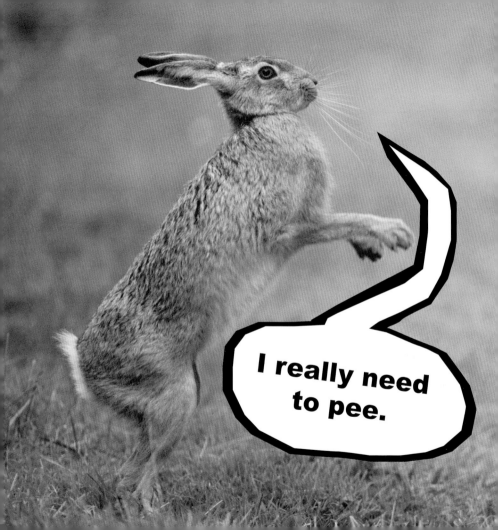

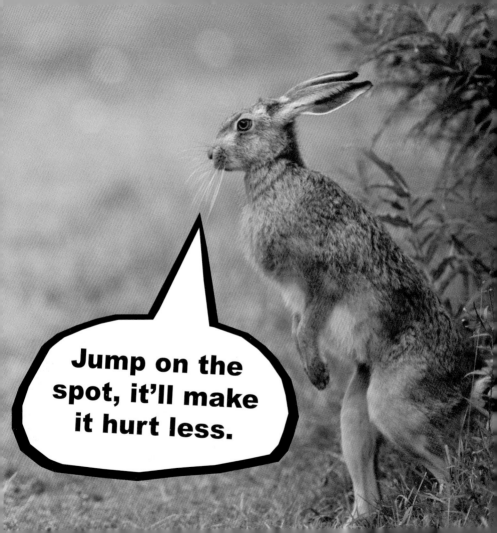

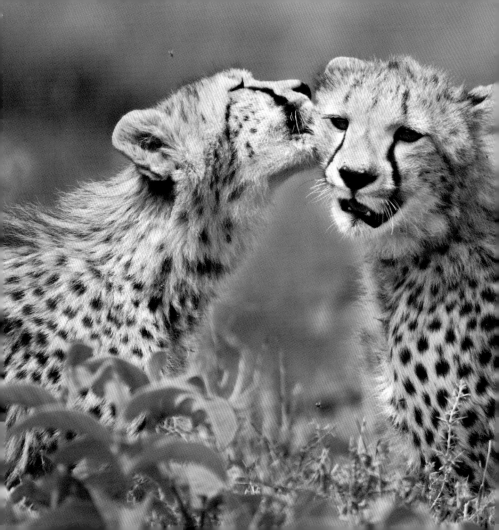

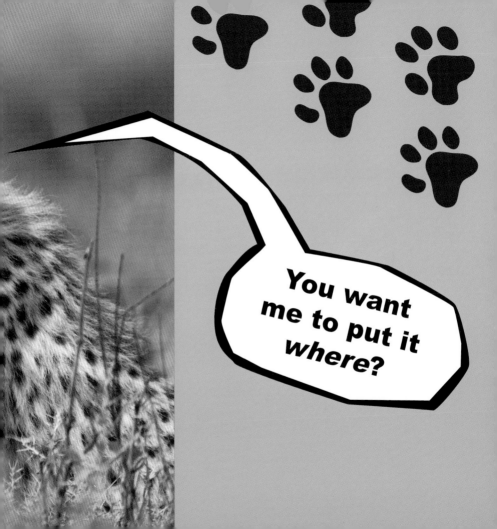

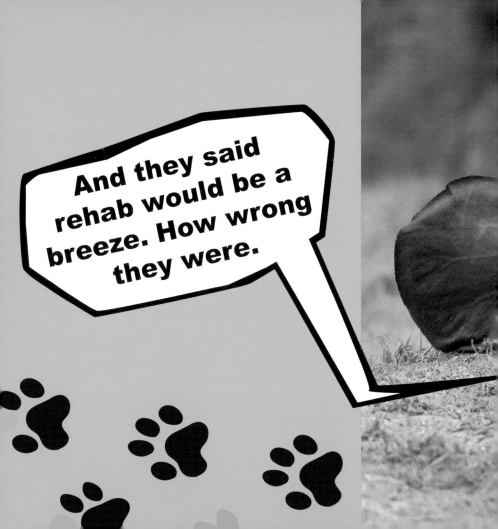

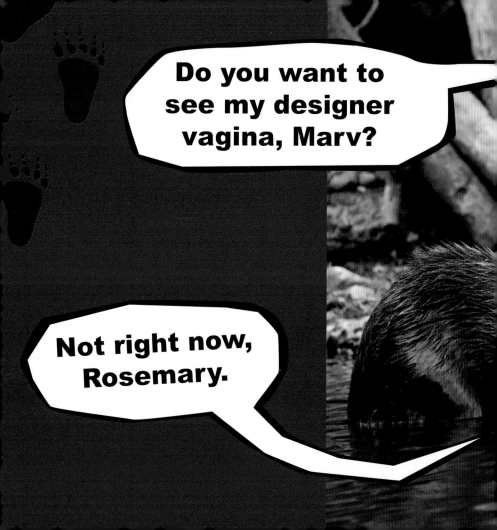

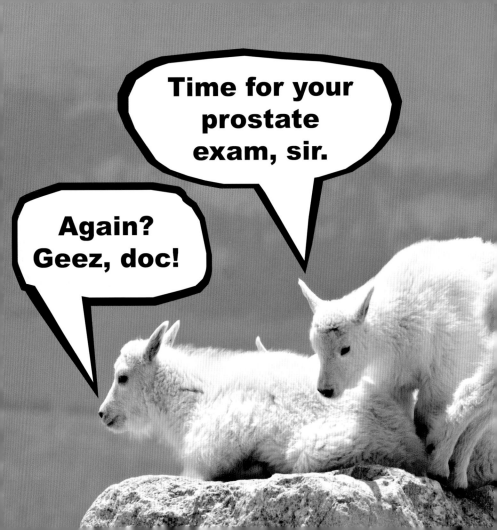

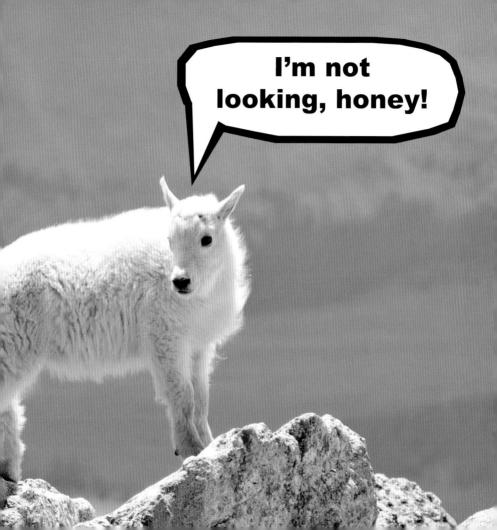

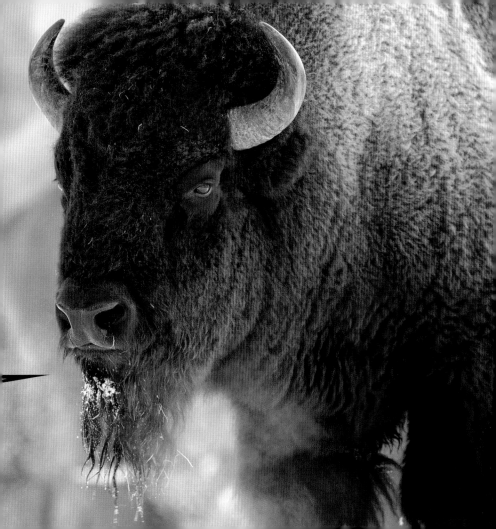

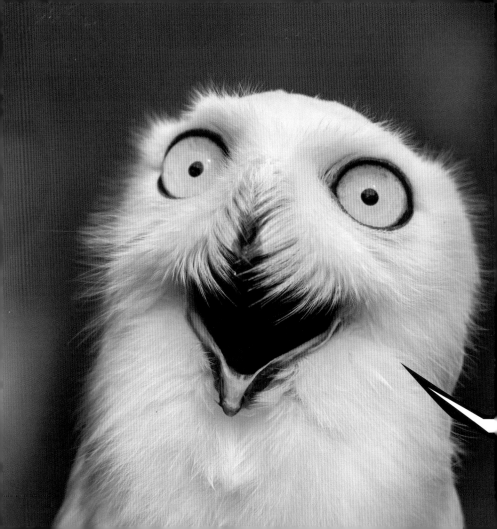

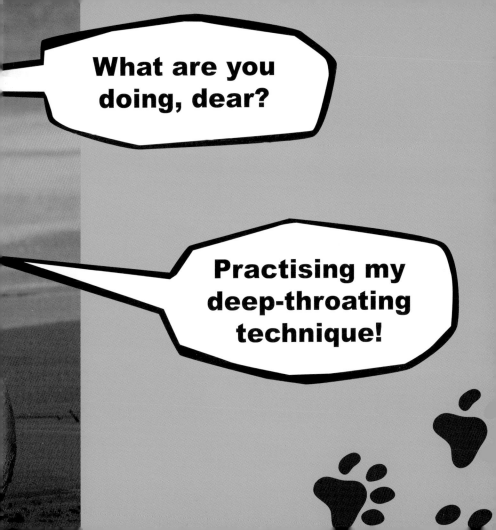

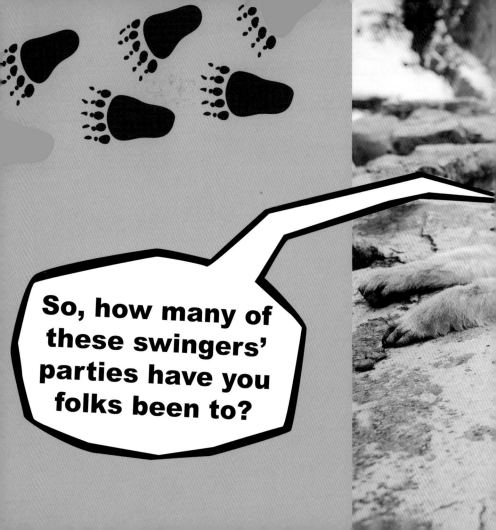

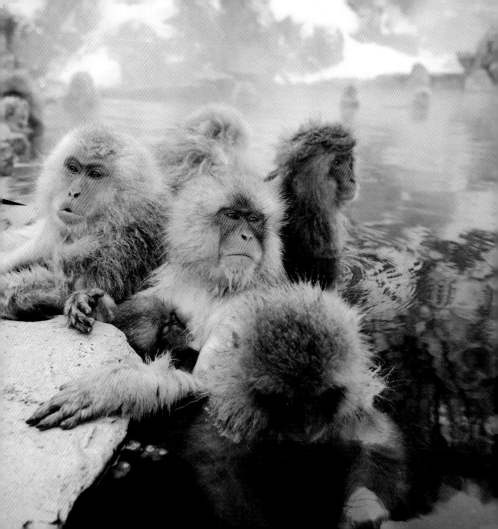

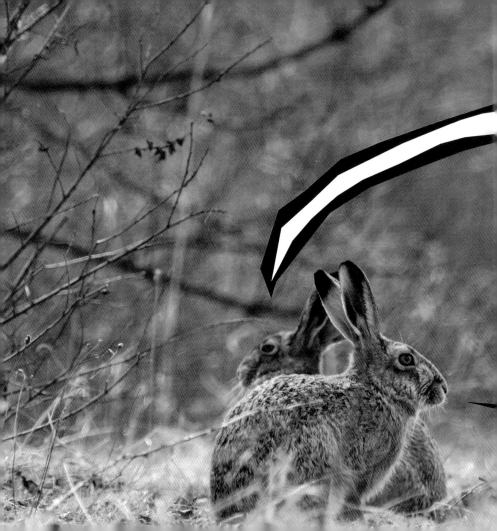

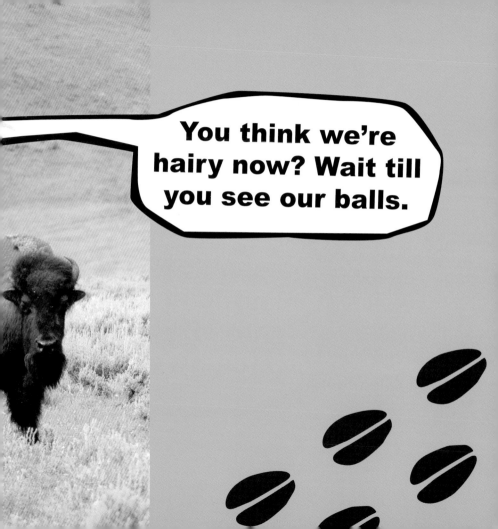

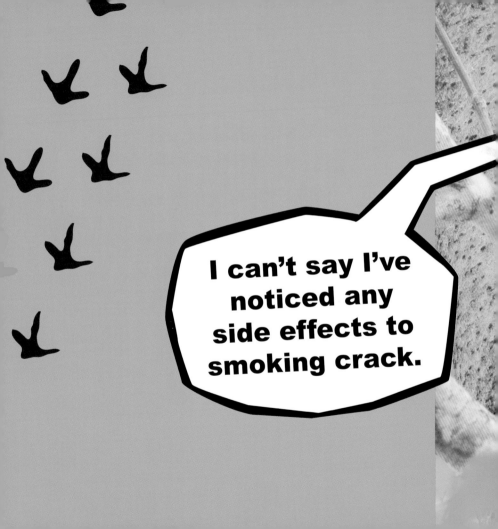

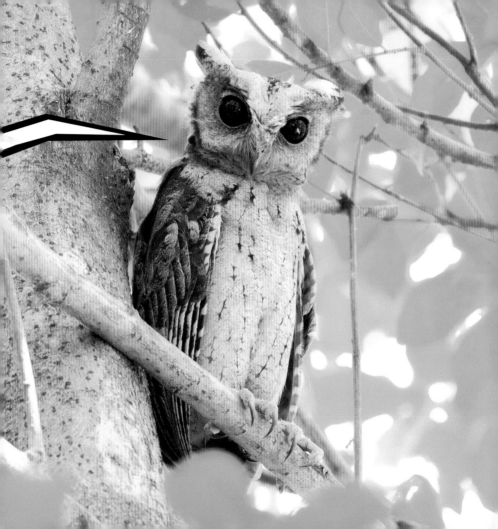

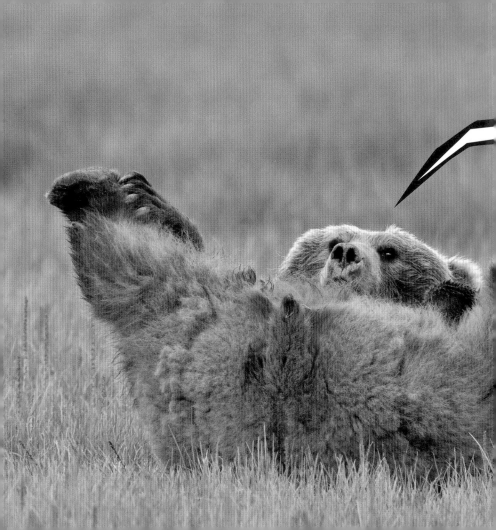

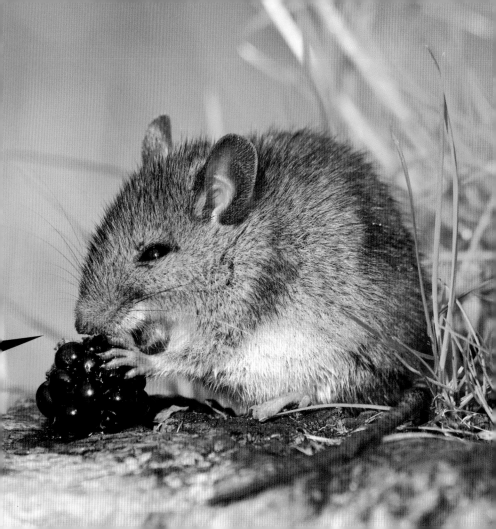

Photo Credits

This was the exact face	© Alberto Loyo
My nose looks like a testicle	© Ronald van der Beek
A bit 'off-road'	© BlueMoonStore
I can't believe you shot him	© Mariusz Potocki
You're wondering what else	© Nagel Photography
More than one wife	© Chris Alcock
I'm seeing double	© Joel Shawn
Read the story again	© katielittle
I'm so horny right now	© EcoPrint
The zebra behind us	© nelik
You've got curves	© cmgirl
Leave the money on the table	© Jan Gottwald
Hand on my dick	© John Carnemolla
Flowers make up for everything	© Sergey Uryadnikov
Good news, bad news	© arturasker
You know that movie	© Santia
Tequila shots	© BMJ
That curry was immense	© Vladimir Melnik
Why are you always hassling me	© Vladimir Melnik
Jumping from the roof on acid	© paul cowell
Come and have a go	© outdoorsman
Pubes in my teeth	© hammett79
Old enough to be my mother	© Pim Leijen
Compensating for something	© Dmitry Laudin
My nuts	© Andrea Izzotti
I really need to pee	© bikeriderlondon
Put it where	© Maggy Meyer
Rehab would be a breeze	© Peter Betts
My tan is completely natural	© nevenm
My designer vagina	© Alan Jeffery
Time for your prostate exam	© Sharon Day
Weed's for pussies	© Nagel Photography
My new face lift?	© rujithai
I'm not a stripper	© PCHT
Mr Pink	© John Carnemolla
If you haven't got any ID	© Maridav
My deep-throating technique	© creativex
Swingers' parties	© SeanPavonePhoto
The drugs will be in an unmarked bag	© TSpider
I mainly like to be taken from behind	© KA Photography KEVM111
You think we're hairy now	© Jeff Banke
Side effects to smoking crack	© tanoochai
Bear pussy tastes like honey	© G-ZStudio
Some nights I like to kick back	© CreativeNature.nl

If you're interested in finding out more about our books, find us on Facebook at **Summersdale Publishers** and follow us on Twitter at **@Summersdale**.

www.summersdale.com